Dear Lauren,
Thank you so m... ...
swapping night ...
me. The Badgers ... ...ly
appreciate it ...

    Love Lisa Fanny Knockers
        + xx
     The Badgers
       xx

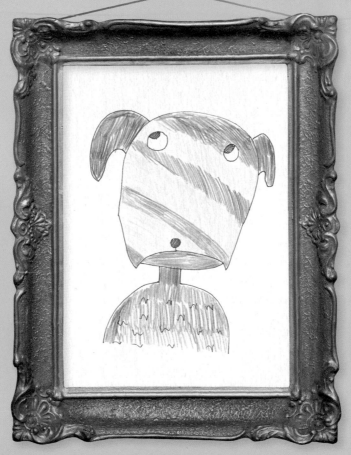

For Sam

# RubbishPet
## Portraits

HarperCollins*Publishers*

# Introduction

I've been called lots of different things in my life. I've considered myself to be very few. An artist certainly isn't one of them.

Apart from the odd doodle on the back of an envelope while patiently waiting on hold to my electricity provider, I've never really drawn in my life. Art was never even a hobby, never mind something I attempted to take seriously.

But all of that changed one afternoon when I was trying to coerce my young son, Sam, into making some thank you cards for my mam and dad. Being a six-year-old boy, Sam would rather be playing on his computer, getting muddy outside or wiping bogies up the wall than sitting down with me and doing something vaguely resembling schoolwork. So, to get him interested in the pens and paper that I'd laid out on the dining-room table, I drew a picture of our dog, Narla. It was rubbish. But it did the trick because Sam was suddenly interested in what I was doing and swiftly came to join in.

While Sam was cracking on making the cards, I decided to attempt to draw a couple more pictures of Narla, this time trying my best to copy some photographs that were saved on my phone. They were rubbish. So naturally I stuck them on Facebook with the following comment:

By the end of the day I'd drawn six commissions for people! Of course, I didn't really charge £299; I didn't charge anything. It was all just a bit of fun between friends. However, just two days later my portrait requests were into double figures and I was beginning to receive friend requests from people I didn't know, asking for pictures.

By day three, I had a waiting list of over twenty people, so to see how far the joke might go, I set up the Facebook page 'Pet Portraits By Hercule'.

It was, of course, all very tongue-in-cheek, but the tone was that I'd now gone into business due to the popularity of my portraits, and that's when the idea for the **Just Giving fundraiser** was born.

I'd drawn a picture of my friend's Golden Retriever, Jess, and Matt (Jess's owner) was insistent on paying something for it. But the portrait was rubbish and there was no way I was accepting his hard-earned cash for it. So, as a compromise, I told him to donate some money to our local homelessness charity, Turning Tides. He duly obliged and came back to me with the suggestion of setting up the Just Giving page.

And that's when it all started to change …… very quickly!

When we set up the Just Giving page, I set the target amount as £299 (the spoof recommended retail price of one of my pictures). I remember me and my wife, Ashley, laughing on the sofa together at the thought of making £299 for charity by selling my portraits of people's pets.

After just one day of fundraising we'd raised £120, and suddenly that dream of making £299 started to feel like it could be realised. It took just two more days.

The Facebook page started to grow in numbers; the portrait requests went from the tens to the twenties and well into the hundreds, and, by default, so did the donations to Turning Tides.

By the end of week two we'd raised £800, week three £2,000, and then the media attention started to come. First, a few of the bigger online media outlets picked up on the story, then one of the national Sunday newspapers. The fundraising jumped to £5,000.

If I thought that was crazy, nothing could have prepared me for what came soon after when the BBC picked up on the story. A local BBC journalist interviewed me and posted an article on their regional BBC news site. By the end of the day it was on the front page of the main BBC News website and I'd received a call to appear on *BBC Breakfast* the following morning.

What followed was a whirlwind few days of worldwide television appearances, radio interviews and telephone calls with journalists. The fundraising leapt to £12,000 in less than 24 hours of the first TV appearance, and just a few days later we had raised £20,000 for Turning Tides. I don't mind admitting that I cried.

I've been asked many times as to 'why Turning Tides' and, for me, that's simple. There's the old saying 'Charity begins at home' and homelessness is an issue that is within all of our local communities. But not only does charity begin at home, EVERYTHING begins at home ...... with a home.

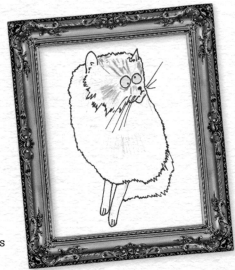

Turning Tides, and the many organisations like theirs up and down the country, work tirelessly to support some of society's most vulnerable people; they provide invaluable services and a helping hand to the men and

women they support. So, simply put, that's why Turning Tides.

As I sit here typing this now, I've drawn over 500 portraits of people's pets and the fundraising is over £55,000. Who knows what it will be by the time you're reading this, but I hope it's more! And if you enjoy this book and want to donate towards the cause, please visit the Just Giving page and chuck in a couple of quid, or whatever you can afford:

**https://www.justgiving.com/
fundraising/portraitsbyhercule**

I said at the start of this, I've been called many things in my life. Can I now *really* be called an artist? I'll let you decide …

**Much love, Hercule x**

This is my dog **Narla** and the picture that started this whole adventure. *Stick it on Facebook; what's the worst that can happen...?* I thought.

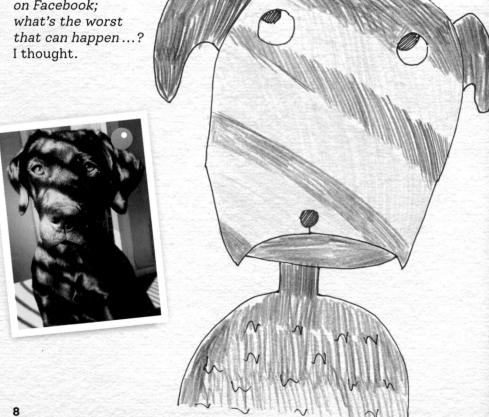

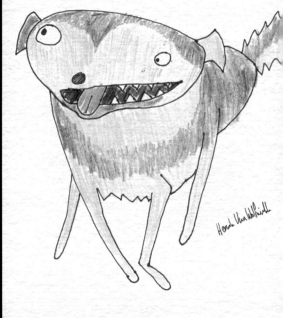

My very first commission. This is **Kiki**, who belongs to the wonderful Kaylea. Kiki likes running in the woods, playing with stuffed toys and finding a bargain down the pound shop.

**Review from the customer:** 'Instead of drawing, maybe you should think about taking up painting? Like the fence? That would keep you busy …'

This is the wonderful **Rafiki**. I'm not entirely sure what breed of dog he is as the photo sent in by owner Nick didn't have Rafiki's body showing. I've had to use some artist licence to finish the portrait, but I think I've pulled it off.

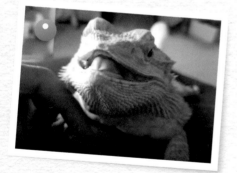

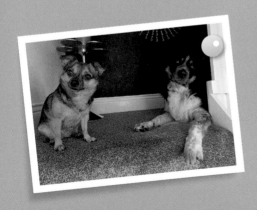

This pair of mischievous pooches belong to the lovely Ian and Cheryl, and their portrait was a chance to show off my two drawing styles – contemporary black and white or ultra-realistic full colour. I don't know what they're called, but I've named them **Sunny** and **Share**.

**Review from the customer:**
'So this is the cost of disappointment, is it?!'

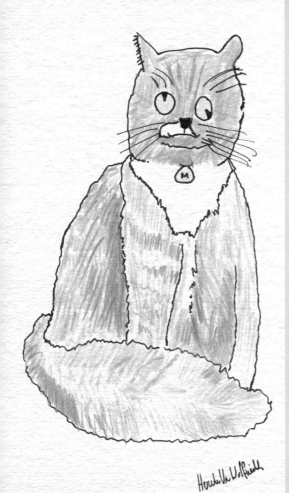

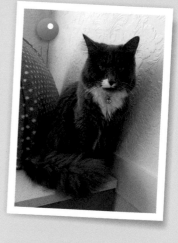

This gorgeous Yorkshire Terrier cross is called **Misty**, and she belongs to the lovely Marielle and family. Misty likes peeping out of boxes, gluten-free tuna and extreme weather.

**Review from the customer:** 'If nothing else this has taught me a valuable lesson about being more careful with my money. Oh and her name is MITZY.'

This daredevil belongs to the Williams family. I don't know what she's called, but I've named her **Melanie Moped**. Mel likes long walks in the rain, the feeling of wind around her ears and the *Top Gun* soundtrack.

**Review from the customer:** 'This would look great displayed on the Louvre. Not the gallery, the louvre doors on my airing cupboard. On the inside of the doors.'

Hercule Van Wrinkle

**13**

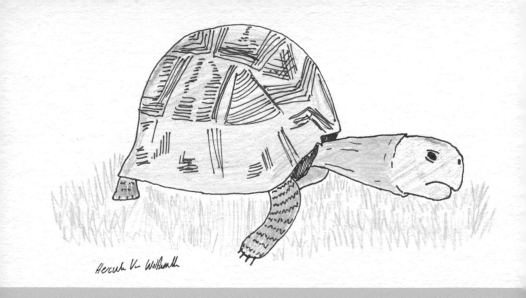

This exotic little fella belongs to the Storey family. I'm not sure what his name is, but I've been calling him **Alexander Graham Shell**. This is the first armadillo I've drawn and I think I've nailed it.

**Review from the customer:** 'He's going to live to be 100 years old and I still don't think that's enough time to get over this.'

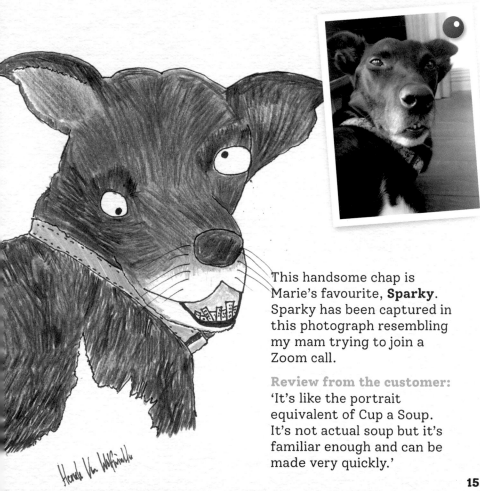

This handsome chap is Marie's favourite, **Sparky**. Sparky has been captured in this photograph resembling my mam trying to join a Zoom call.

**Review from the customer:**
'It's like the portrait equivalent of Cup a Soup. It's not actual soup but it's familiar enough and can be made very quickly.'

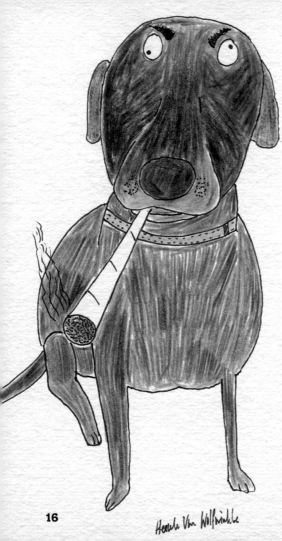

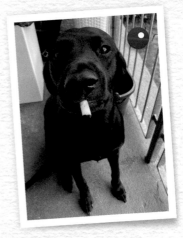

This beautiful girl belongs to Tia. I think she's called '**Pls**'. Tia's message just read: 'draw my dog pls'. Not sure how it's pronounced, it might be Irish.

**Review from the customer:** 'Why have you drawn her with a fag in her mouth?! She doesn't even smoke anymore.'

Hercule Van Wolfwinkle

I loved drawing this handsome chap. And what a clever boy he is; apparently he can balance that ball on his head for about twenty minutes.

**Review from the customer:** 'Tell ya what, mate, why don't you get back to me when you've drawn a picture of my actual dog.'

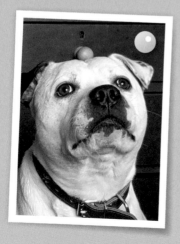

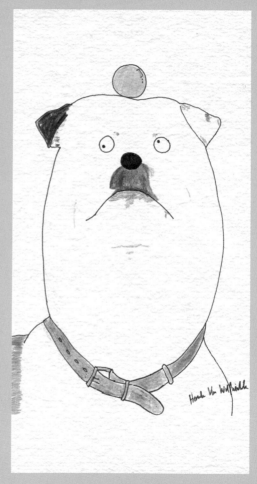

This is the lovely **Marley**, who looks extremely dashing in his wellies. Sadly, Marley is no longer with us, and I really wanted to do his family proud with this one.

**Review from the customer:**
'We really miss Marley. If I ever think I might be forgetting what he looked like, I can gaze at your portrait and know it was nothing like that.'

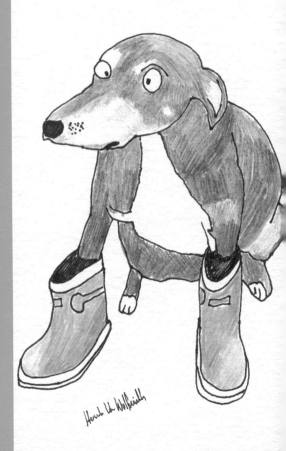

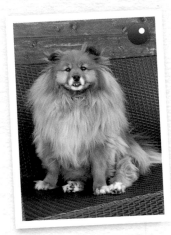

This is **Ossie Pie**. Don't be fooled by his name, though, Ossie isn't actually a pie. I'm no expert, but I believe he's a crossbreed lion.

**Review from the customer:** 'Have you missed a decimal point out of your prices cause there's absolutely no way that this picture is worth anything more than a meal deal from the BP garage.'

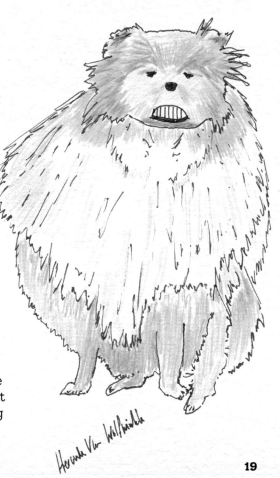

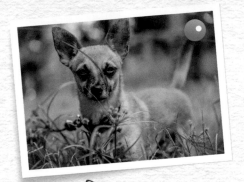

This little ferret belongs to Amber. I don't know what she's called, but I've named her **Louise Cheese**. Louise likes sleeping under the coffee table, the high jump and amateur roadworks.

**Review from the customer:** 'It's as if my eyes have stood on Lego.'

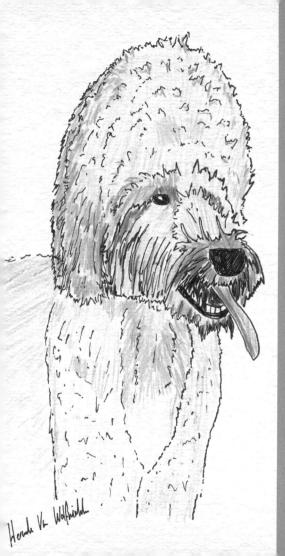

This is Francesca's handsome pooch. I've named him **Gavin Garnier** because he has a hairstyle that is the envy of the whole dog park.

**Review from the customer:** 'There isn't a wall in my house discreet enough to hang this from. I knew we shouldn't have gone open-plan but my other half just couldn't wait to order his bloody bifold doors.'

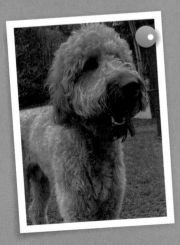

This is **Boycie**, who is long retired from his days at the greyhound stadium (he used to work behind the kiosk serving chicken and chips in baskets). He still loves to stretch his legs every now and again with a trip down KFC.

**Review from the customer:** 'This reminds me of that time I accidentally farted on the bus; it's embarrassing and it stinks.'

This Labrabarndoor belongs to Jo. I've named him **Justin Woodpuddle**. Justin is well loved and looks extremely happy despite his bad leg.

**Review from the customer:** 'I'm a girl of simple pleasures; you should meet my husband. But even I can't find anything good to say about this. I was really looking forward to getting this portrait. Now I'm just looking sad.'

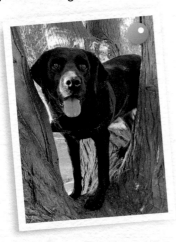

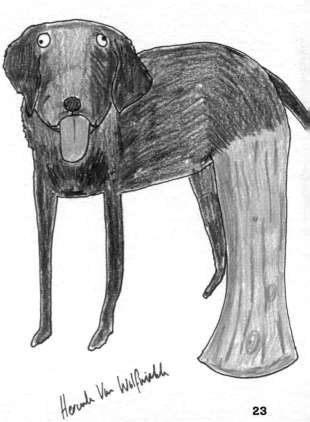

Herman Van Wolfswinkel

A scary one here, so probably don't show the kids. I'll be honest – it was quite frightening drawing this picture of a cat looking at a ghost, but I still think I managed to capture it perfectly.

**Review from the customer:** 'You will be hearing from my solicitor.' [I just love it when a customer refers me to others; there is no greater compliment.]

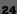

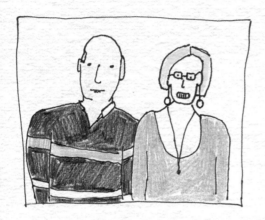

Not really my usual thing, this, but when I got a lovely message kindly asking me to 'please draw this wonderful couple' I thought, 'Yeah, why not'.

**Review from the customer:** 'I mean, I thought I was clear … You do PET PORTRAITS … ARE YOU STUPID?!'

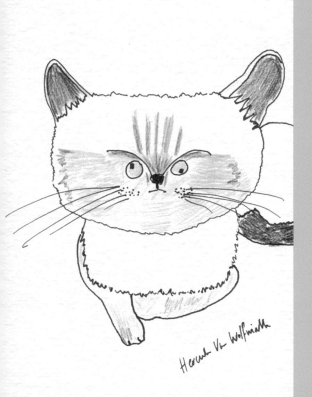

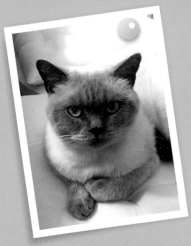

This beauty belongs to Clair or Clare or Claire (you're never quite sure, are you?). She was a real treat to draw and I think I've captured her perfectly, as ever.

**Review from the customer:** 'The more I cried and the blurrier it looked through the tears, the better I thought it was.'

They say human hands are notoriously hard to draw, but I liked how the photo hinted at the cat getting a cuddle and I wanted to capture that. I think I've dispelled the myth that hands are hard to draw.

**Review from the customer:**
'I honestly think you're deluded enough to believe this looks good. What's the point in trying to leave a constructive review?'

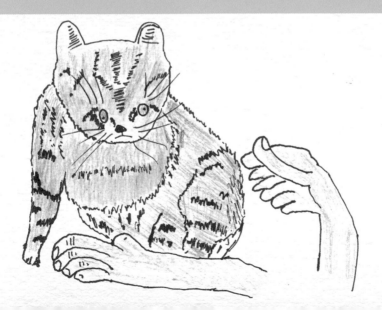

Hewah Van Wilrickt

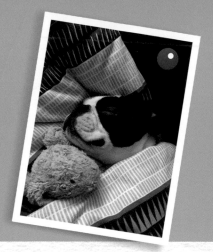

This is the first rabbit I've drawn and I think I've captured her perfectly, from the photo of her sleeping with a Boston Terrier.

**Review from the customer:**
'I've been waiting ages for this. FOR THIS! It's like burning your mouth on the first bite of a pizza you've been really looking forward to. But with your eyes. And it's not pizza, it's your drawing.'

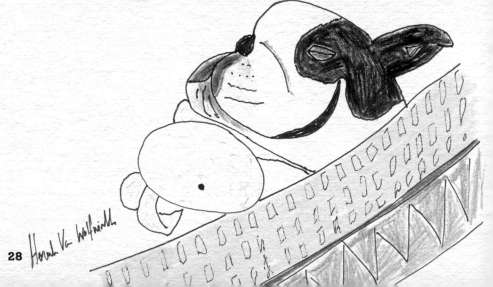

28 Hannah Van Wolptinkle

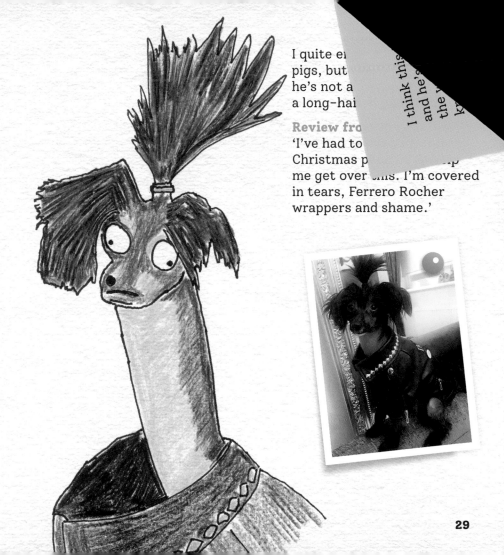

I quite e[njoy]
pigs, but [                ]
he's not a [            ]
a long-hai[red]

**Review fro[m]**
'I've had to [                ]
Christmas p[                ]
me get over this. I'm covered
in tears, Ferrero Rocher
wrappers and shame.'

I think this [          ]
and he's [          ]
the [          ]
k[          ]

... is a young badger ... being hand-raised by ... wonderful Tanya. I don't ...ow what he's called, but I've named him **Ricky Ringtone**. I'm told he's always smiling and I've done my best to capture that in my drawing.

**Review from the customer:**
'You've made my children cry.'

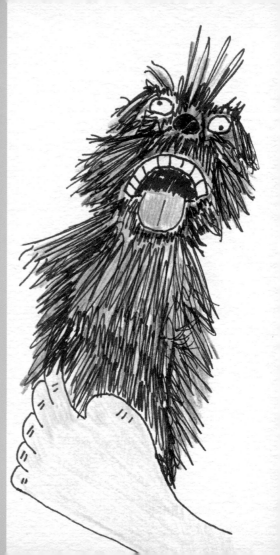

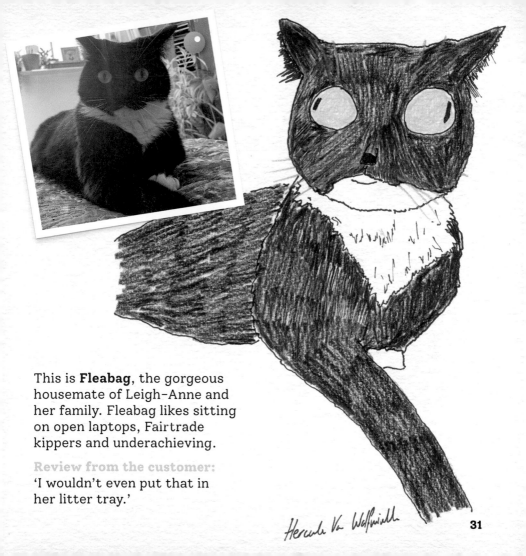

This is **Fleabag**, the gorgeous housemate of Leigh-Anne and her family. Fleabag likes sitting on open laptops, Fairtrade kippers and underachieving.

Review from the customer:
'I wouldn't even put that in her litter tray.'

Hercule Van Wolfwinkle

**31**

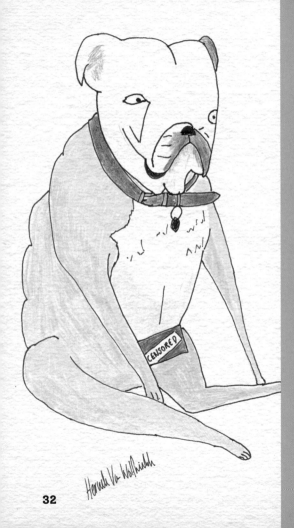

This handsome fella belongs to Stef. I don't know what his name is, but I think he looks like that old famous politician John Prescott.

**Review from the customer:** 'It looks OK if I stand at a distance and squint. Or get really drunk ... Which I have done on numerous occasions since realising I've spent £299 on this shite.'

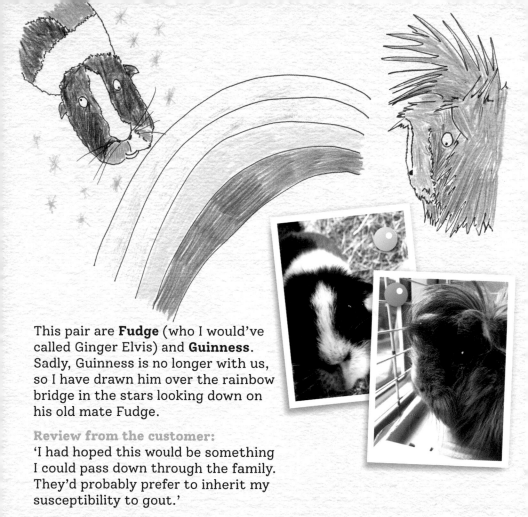

This pair are **Fudge** (who I would've called Ginger Elvis) and **Guinness**. Sadly, Guinness is no longer with us, so I have drawn him over the rainbow bridge in the stars looking down on his old mate Fudge.

**Review from the customer:**
'I had hoped this would be something I could pass down through the family. They'd probably prefer to inherit my susceptibility to gout.'

This sleeping beauty belongs to the lovely Laura. I don't know what she's called, but I've named her **Pauline Payback**.

'It actually starts out quite decent but it turns into chaos faster than an 18–30s night out in Magaluf. It's kind of like Dante's descent into hell as your eyes move across the page.'

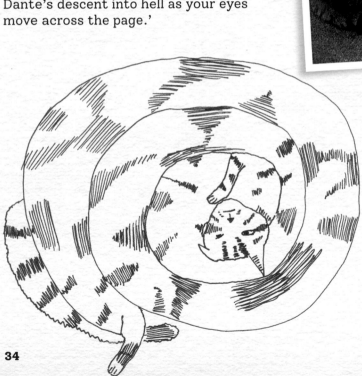

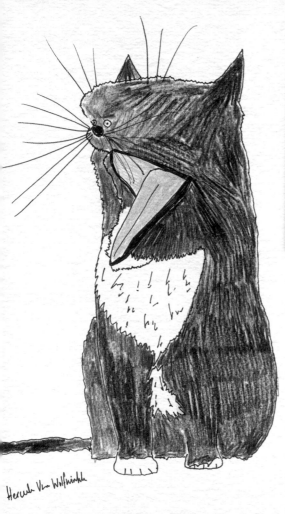

Hercule Van Wolfwinkle

**Review from the customer:**
'We rescued **Daisy** from the RSPCA. Well, we didn't actually rescue her from the RSPCA as such; it's not like they were mistreating her or anything. The RSPCA had rescued her and then we took her from the RSPCA … Anyway, it's taken us seven years to get Daisy to trust that people can be good and now you expect me to show her this?!'

35

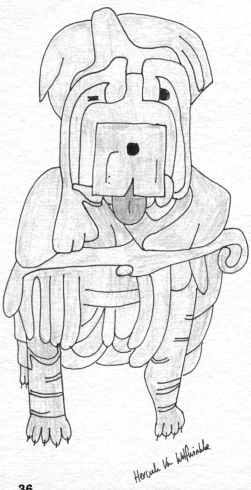

This ... erm ... cat? Dog? Shaved lion ...? Well whatever it is, she's beautiful.

**Review from the customer:** 'It looks like someone has taken a load of jigsaw pieces and just rammed them together until it vaguely resembles a picture'.

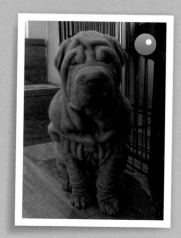

'Could you draw my dwarf cat for me, please?' asked Georgina. Of course I can, Georgina, of course I can …

Hercule Van Wolfwinkle

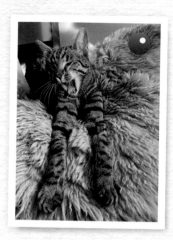

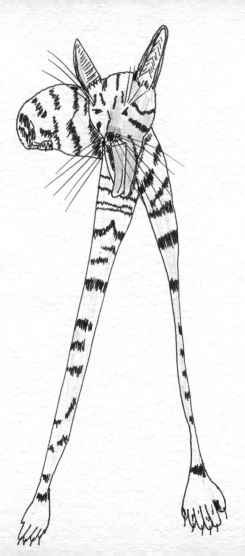

Folks, meet **Salvador**. He belongs to friends of Emma but, being honest, he looks like he should probably be living in the wild. Salvador likes staying out late, sifting through bins and South American punk rock.

**Review from the customer:**
'You know I said this was a gift for friends? Perhaps I should have been clear that they ARE FRIENDS I WISH TO KEEP!'

This fluff ball belongs to Anna and I've named him **Frank Fidget**.

**Review from the customer:** 'Can you grab fourteen boxes of eggs and banana Frijj milkshake when you go to Tesco?' 'Sorry, that last message wasn't meant for you. LOL! What am I like?! The portrait is rubbish.'

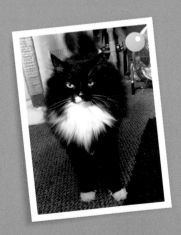

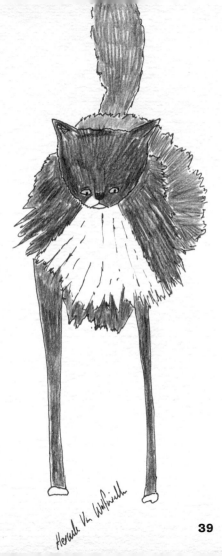

Hercule Van Wolfwinkle

Absolutely delighted to announce that Zippy has just had a child. Of course not! This is obviously an Axolotl (I think I got really drunk on that one night in Zante about 15 years ago).

**Review from the customer:** 'This is my daughter's pet. She saved up all her pocket money for this. I hope you're pleased with yourself.'

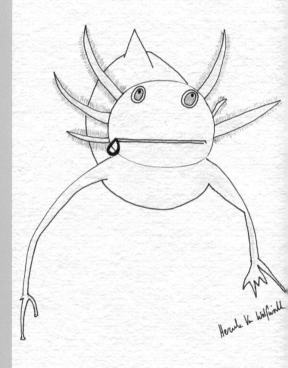

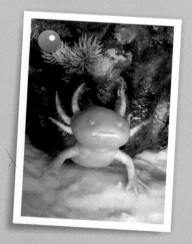

I have a rule of not doing portraits of spiders. I can't draw their legs, they're really hard. Despite this, I have received a few messages from Cheryl asking me to draw her tarantulas. Despite all my best efforts I just cannot get the legs right. I dunno what I find so hard about them, but they are impossible. Let's *never* speak of this again.

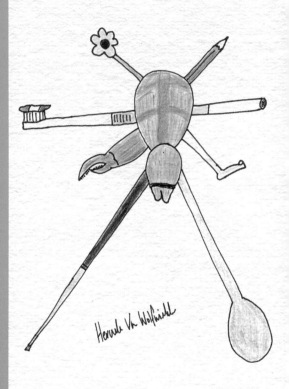

Hercule Va Wolfinckl

41

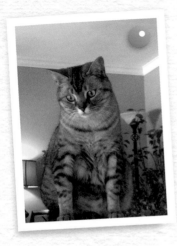

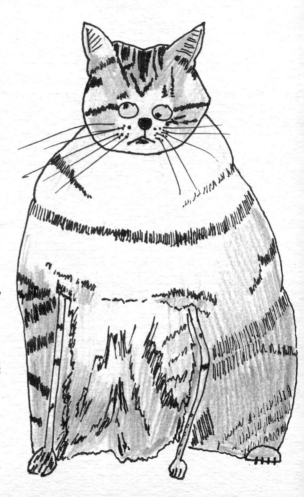

This is **Natas**, who was rescued by Lynn nearly ten years ago. The name 'Natas' is Portuguese and it loosely translates to 'the grey cat at the buffet table'.

'I rescued this cat. He had a really tough start to his life, but believe me when I say that this is probably the worst thing that's ever happened to him.'

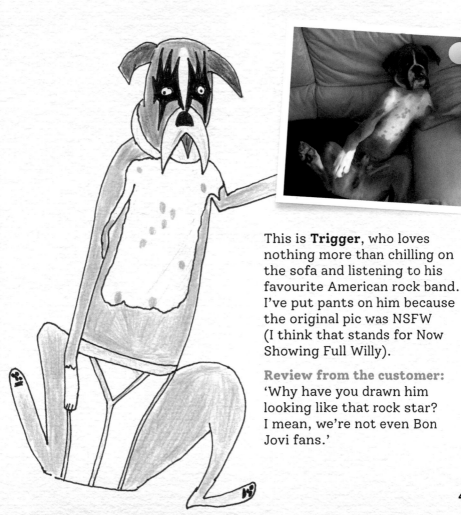

This is **Trigger**, who loves nothing more than chilling on the sofa and listening to his favourite American rock band. I've put pants on him because the original pic was NSFW (I think that stands for Now Showing Full Willy).

**Review from the customer:** 'Why have you drawn him looking like that rock star? I mean, we're not even Bon Jovi fans.'

43

This little chap is called **Wolfie**. I'd like to think his owner Jeannie named him after me, but I doubt it. He's sitting in a bag in the photograph, but I've decided to draw him in his full glory in my pic.

**Review from the customer:** 'My expectations were low, but they're practically doing the limbo now.'

This handsome boy belongs to the lovely Siobhan Kelly. I've called him **Sid Rory Weaver**. Sid likes a decent look-out spot, being engulfed by fog, and shirts requiring cufflinks.

'I've shown everyone I know. They all hate it. Even the bin man posted it back through my letterbox.'

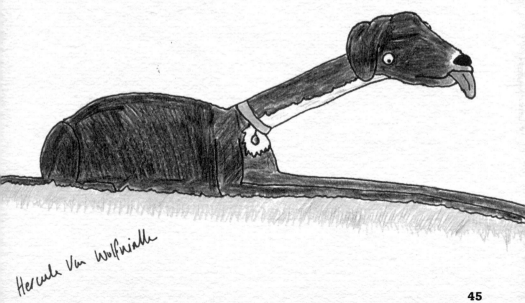

Hercule Van Wolfwinkle

This is **Bosun**. Bosun lives with Lee-Anne and Andy. Bosun can bark in three different languages, and in his spare time he likes chasing tennis balls and hanging out down the youth club.

**Review from the customer:**
'This was due to be a gift for my husband and, well, I suppose that's one way to tell him I want a divorce ...'

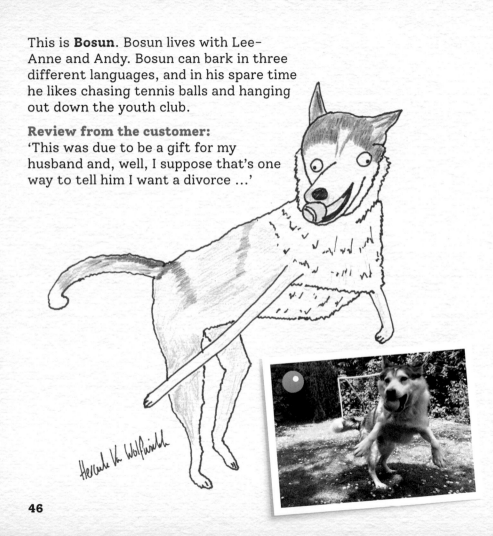

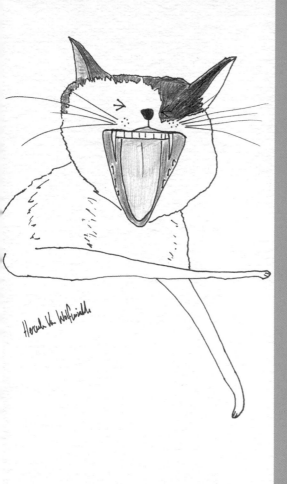

This little joker is **Boris** and he belongs to Bobby Hopkins. Boris loves climbing the curtains, playing with feathers and BBC Radio 4.

**Review from the customer:** 'It reminds me of a CD I stole in Spain once: *Boyzone Classics on Panpipes*. Each song was vaguely similar to the original, but just really sodding awful.'

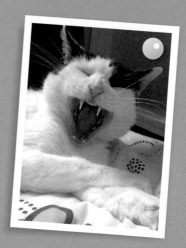

47

This portrait was requested by Cody as a gift for her mum. I'm not exactly sure what this is, but I'm guessing maybe a long-haired Bolivian squirrel.

**Review from the customer:** 'This was supposed to be a gift for my mum. It's her birthday in two days. I've got no time to go shopping and all I have is an Avon catalogue. Cheers.'

This fella climbed onto a wardrobe in 2014 and won't come down. His owner just chucks him up eight meals a day.

**Review from the customer:** 'I'm a big fan of your work and I really WANT to like this … I've put it up in the lounge. I suppose it looks OK if I stand back from it, like in the hallway. With the door shut.'

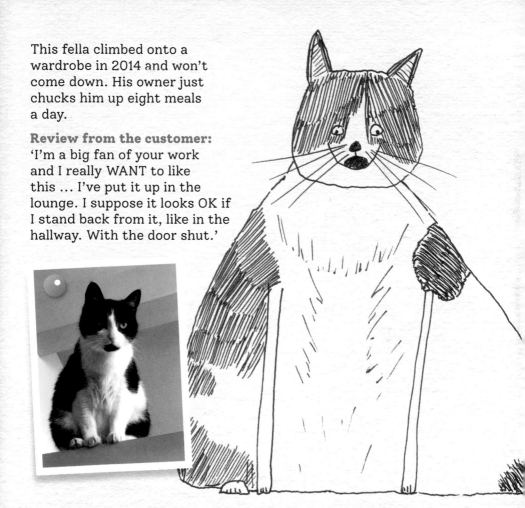

I'm not sure if this is an actual dog or an oversized puppet that's been pinched from the evening entertainment at an all-inclusive holiday in Majorca.

**Review from the customer:**
'I know all art is subjective. There's probably someone out there who likes this. If by some miracle you find them, let me know and I'll happily hand it over.'

Hervé Van Wolfmalle

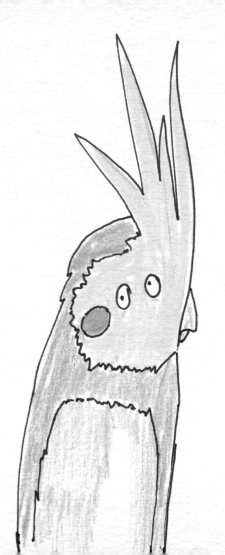

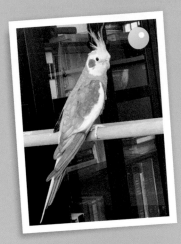

I think this is a kingfisher and he belongs to Sarah, who lives all the way over in the USA. He's called **Jack**. I asked Sarah if she thought Jack would be able fly to the UK; she's said no. She's always putting him down.

**Review from the customer:** 'We're all in tears. Sad and angry tears. Not even the good kind of tears.'

This cat has the brightest eyes I've ever seen. I think I've captured that perfectly in my drawing.

**Review from the customer:**
'They say Eskimos have over four different words for snow. It might even be more than that; I can't quite remember. Anyway, they also say a picture is worth a thousand words, and in this case ALL those words are "sh*t".'

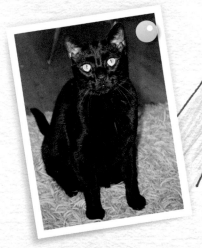

Hercule Van Wolfwinkle

This is **Catty**, who belongs to Chris Coe, a man with far more important things to do than spend time thinking of a name for his cat. Catty is pictured sitting with her favourite Martin Kemp doll.

**Review from the customer:**
'We love it! It's really REALLY great. Amazing! Honestly. We definitely love it. Never message us again and please stop leaving those weird voicemails.'

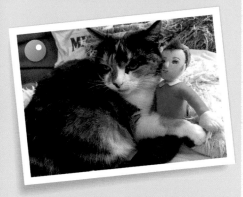

Hercule Van Wolfwinkle

I'm 81 per cent sure that this is a cat, but there's 18 per cent of me that thinks it might be a cockerpoo puppy and 1 per cent of me that hopes it can't be fed after midnight.

**Review from the customer:** 'It reminds me of that time when the online food shopping turned up and they'd replaced a two-pack of fresh tuna steak with a tin of sardines.'

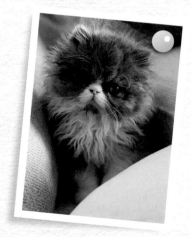

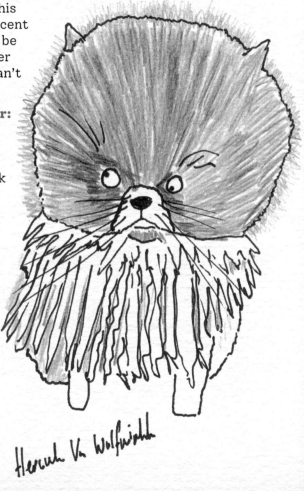

Hercule Va Wolfwright

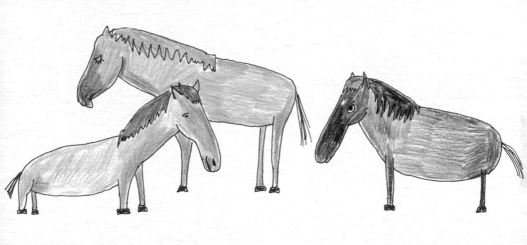

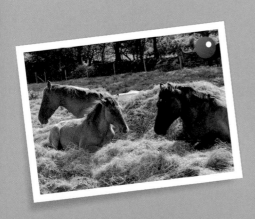

These three belong to Becky, who wanted three separate portraits. But I told her that paper doesn't grow on trees.

**Review from the customer:** 'I've actually just been sick in the kitchen bin. And for the avoidance of doubt, it was because of this picture and the shock it induced. And for the further avoidance of doubt, it wasn't a good shock.'

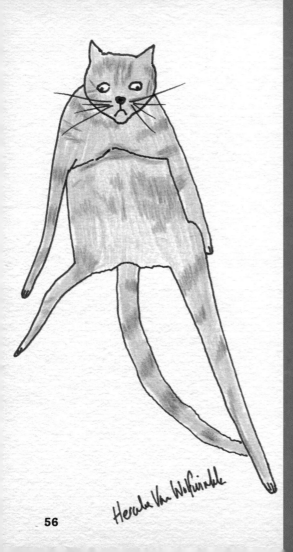

Hannah contacted me and asked if I could draw her cat like 'one of my French ladies'. I've no idea what that means, probably an 'art' joke or something. Anyway, oui, Hannah, oui I can.

**Review from the customer:** 'It's what the French might call ... How you say ...? Merde!' [I think 'merde' means 'thanks'. You're welcome, Hannah.]

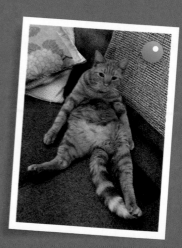

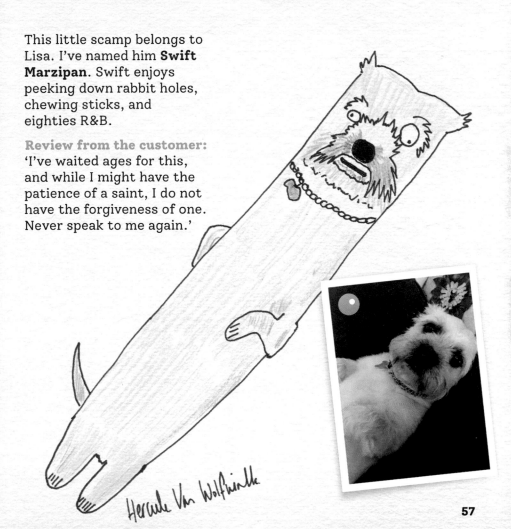

This little scamp belongs to Lisa. I've named him **Swift Marzipan**. Swift enjoys peeking down rabbit holes, chewing sticks, and eighties R&B.

**Review from the customer:** 'I've waited ages for this, and while I might have the patience of a saint, I do not have the forgiveness of one. Never speak to me again.'

Hercule Van Wolfwinkle

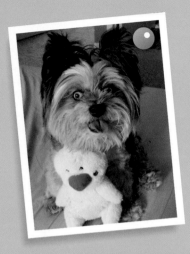

This is the beautiful **Willow**, who belongs to Amy. Willow enjoys eating bread, getting in the water and snuggling up to Amy's dog. Willow is also the first duck that I've drawn, so that's pretty cool.

**Review from the customer:** 'You know I wanted you to draw the dog. I know you know that. I suppose you think you're funny?!'

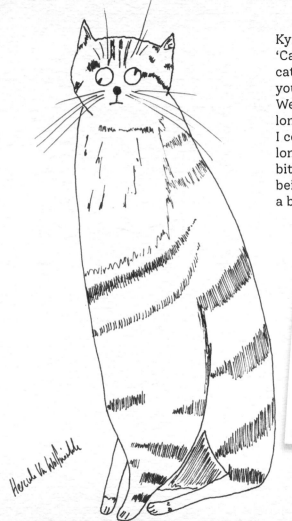

Kyra messaged me, saying, 'Can you draw a pic of my cat please? How long do you think it will be?' Well, I hope I've drawn it long enough for you, Kyra. I couldn't really get it any longer without sticking two bits of paper together and, being honest, that felt like a bit too much of a faff.

Hercule Va Wolfinkle

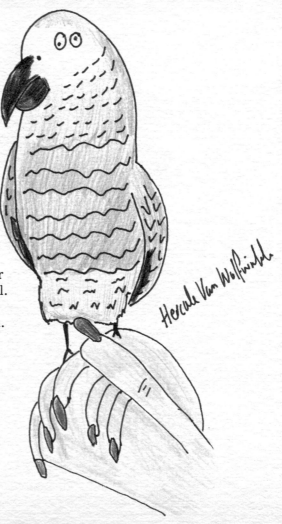

Hercule Van Wolfwinkle

If you're not an expert like me, you might be forgiven for thinking this is a baby seagull. But it is in fact an African Grey. An African Grey pigeon.

**Review from the customer:** 'Maverick can swear like a drunken sailor. There's no way I'm showing him this 'cause we'll not be able to have children in the house for weeks. He'll be livid.'

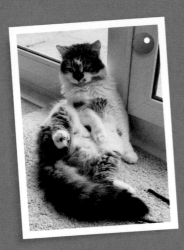

This absolute unit belongs to the wonderful Diane. I don't know what he's called, but I've named him **Cat Damon**.

**Review from the customer:** 'It's a good job I'm always losing my glasses.'

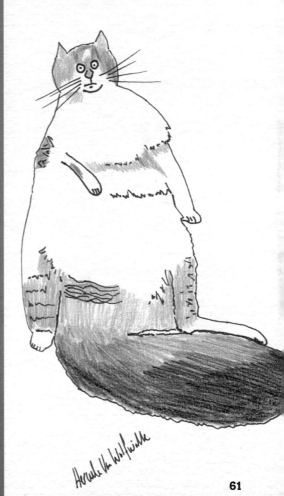

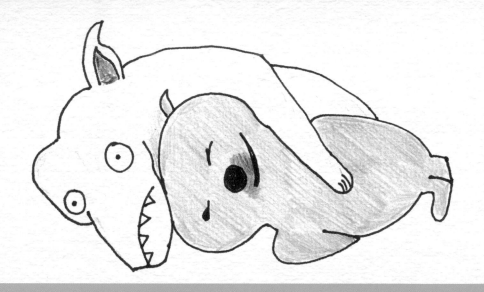

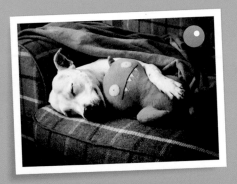

This is the beautiful wee **Poppy** and she belongs to the wonderful Emily. Poppy loves running after birds, chewing on a juicy bone, and semi-professional medicine.

**Review from the customer:** 'One, two, three, four, five, six, seven, eight, nine, ten … Nope, sorry, I'm still too livid to speak.'

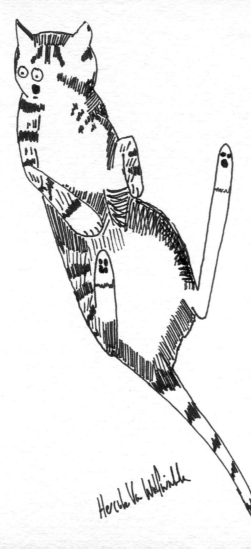

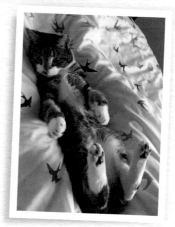

Folks, meet **Lemmy**. Lemmy belongs to Clara and I assume he's named after Clara's favourite rock star, Lemmy Kravitz.

**Review from the customer:** 'Did you draw this in the dark ... With your eyes closed ... And your hands tied behind your back?'

This handsome chap is **Tango**. Tango's days of working down the greyhound track (he was a bookmaker) are long gone and now he enjoys lazy afternoons on the sofa, three square meals a day and being stroked by old ladies outside Iceland supermarket.

**Review from the customer:**
'This is the first time in two years I've had to use my blue inhaler.'

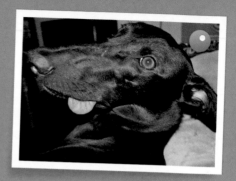

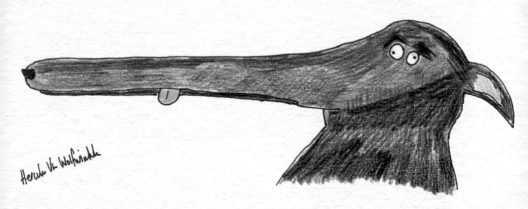

Hercule Va Wolfinrahle

The photo that was submitted here was obviously just the dog's head, so I've had to use all my artistic experience to create the full-body portrait that the owner deserves.

**Review from the customer:** 'It looks like someone has tried to build a flat-pack version of my dog without any instructions.'

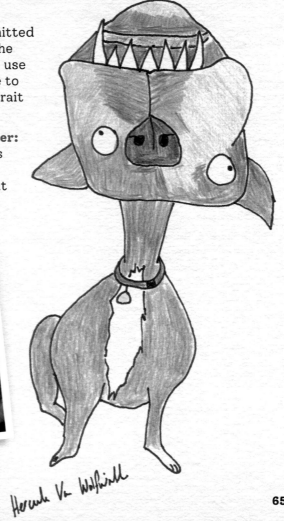

This wise-looking fella belongs to the lovely Sara. I've named him **Brandon Bodega**. Brandon enjoys long walks in the forest, peeking down rabbit holes and authentic Dutch folk music.

**Review from the customer:** 'It reminds me of that time the hoover bag exploded all over my nan.'

66

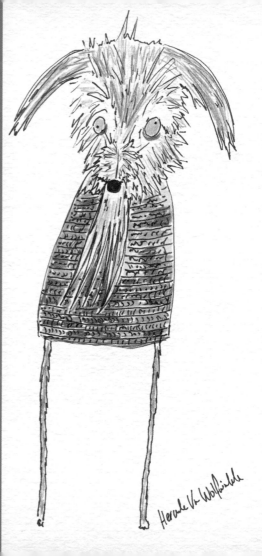

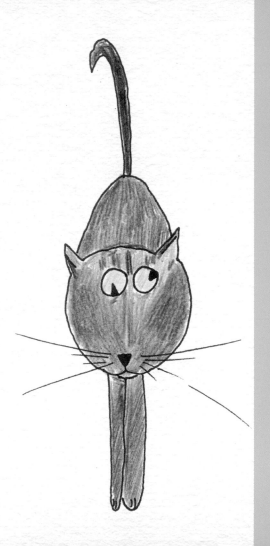

I've named this little cutie **Gwen Affleck**. Gwen likes getting under your feet, stealth mode and those massive Biffa bins round the back of Londis.

**Review from the customer:** 'I'm going to bury it in the garden and hope it doesn't come back to haunt me.'

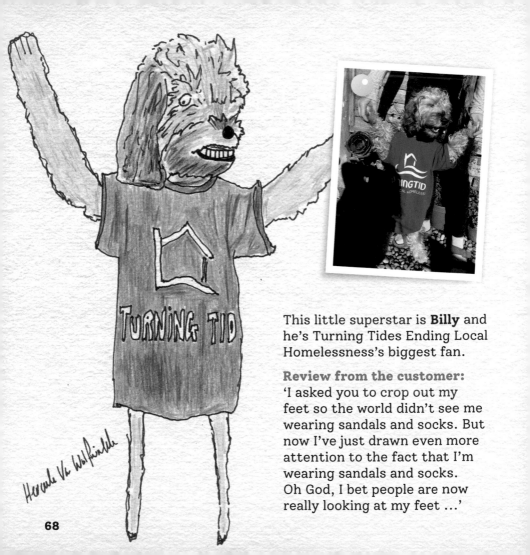

This little superstar is **Billy** and he's Turning Tides Ending Local Homelessness's biggest fan.

**Review from the customer:**
'I asked you to crop out my feet so the world didn't see me wearing sandals and socks. But now I've just drawn even more attention to the fact that I'm wearing sandals and socks. Oh God, I bet people are now really looking at my feet ...'

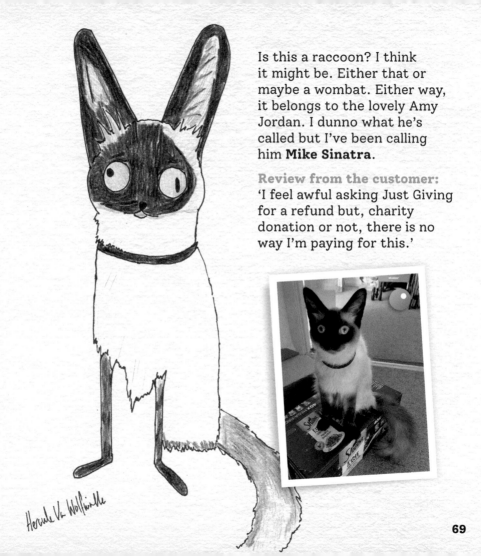

Is this a raccoon? I think it might be. Either that or maybe a wombat. Either way, it belongs to the lovely Amy Jordan. I dunno what he's called but I've been calling him **Mike Sinatra**.

**Review from the customer:** 'I feel awful asking Just Giving for a refund but, charity donation or not, there is no way I'm paying for this.'

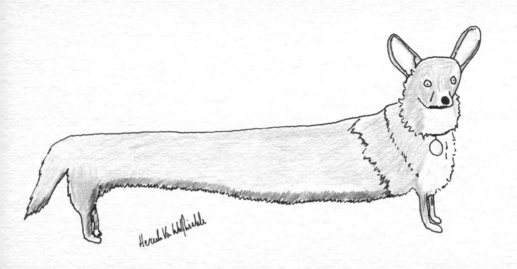

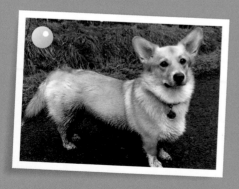

This is **Minnie** and she belongs to the lovely Pauline Wicks. Minnie is a Corgi and I thought she'd be good practice for when the Queen gets her request in.

**Review from the customer:**
'If I kind of fold the paper in half a bit and bring the back legs a bit closer to the front … it still looks rubbish.'

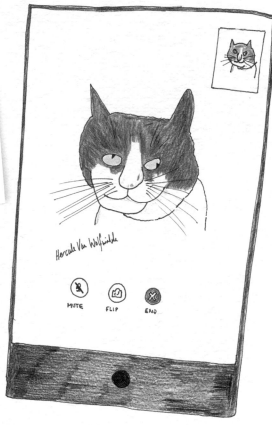

Hercule Van Wolfwinkle

MUTE    FLIP    END

This is **Charlie**, who belongs to Julie Tuttiett. Charlie is captured here looking like my dad trying to hang up a FaceTime call.

**Review from the customer:**
'Dhswiwsnsn dndjdjasd djsisidsjsns fkdosjsjsbsjsjssnsj eeejejeksnsndebejejsdsjj. Sorry about that, I was just trying to wipe the tears off my phone screen …'

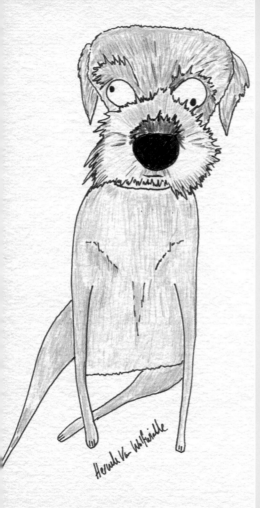

This is **Flapjack**, and she belongs to the wonderful Samantha and family. Flapjack loves chasing seagulls down the beach, playing swingball in the garden and listening to nineties mainstream house music.

**Review from the customer:**
'I was told you'd capture the essence of my dog. Well, you've certainly captured her scent. And let me tell you this now, she STINKS.'

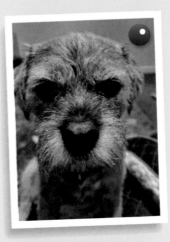

I'm told that this is a rare breed of Belgian Fox Poo Terrier. I'll let you decide if you can be bothered to Google that or not.

**Review from the customer:**
'It's going to take a while to process these emotions. I feel like I want to laugh and cry and scream and cry and scream and cry and cry and cry all at once.'

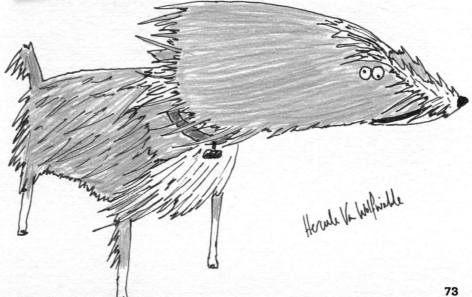

Hercule Van Wolfinkle

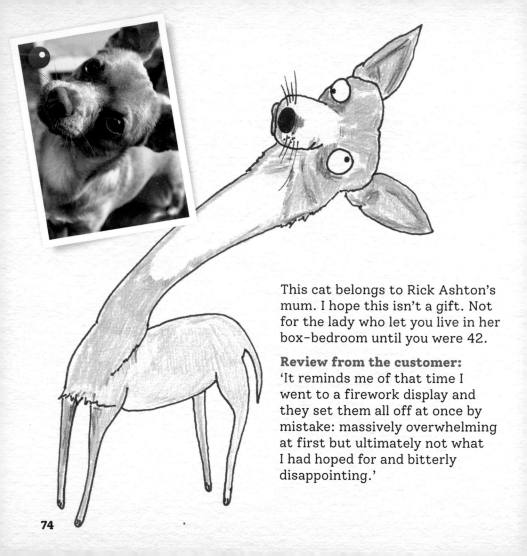

This cat belongs to Rick Ashton's mum. I hope this isn't a gift. Not for the lady who let you live in her box-bedroom until you were 42.

**Review from the customer:**
'It reminds me of that time I went to a firework display and they set them all off at once by mistake: massively overwhelming at first but ultimately not what I had hoped for and bitterly disappointing.'

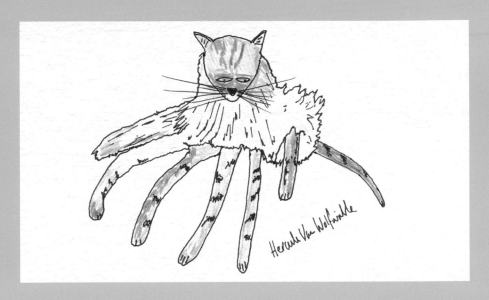

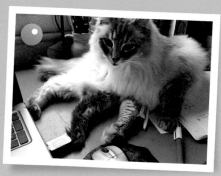

This fine specimen belongs to Samantha Smith. I don't know what his name is, but I've called him **Dr Legg**.

**Review from the customer:**
'You say that getting a portrait done is something of a lottery ... Well, I feel like a vegetarian who has just won the meat raffle.'

The mother-in-law has decided she likes me again now she wants something ... This is **Jenny** and she belongs to my out-laws, June and Clive.

**Review from the customer:** 'Don't ever speak to us again.' [Mission accomplished.]

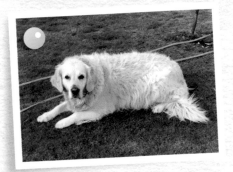

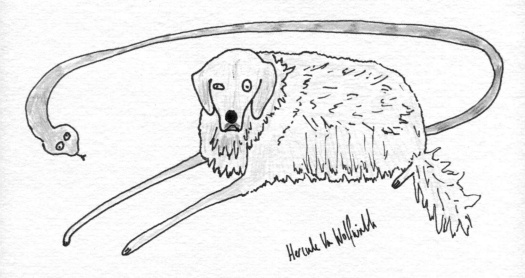

Hercule Va Wolfinkle

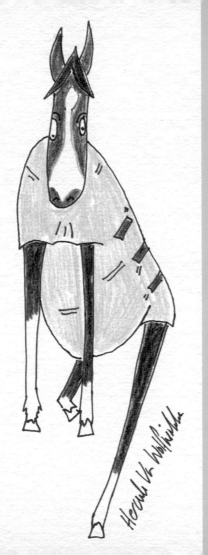

Once more I've proved that it's a massive myth that horses are hard to draw. This stunning chap belongs to Sue, and he's pictured here wearing one of me mam's old dressing gowns.

**Review from the customer:** 'You've actually just reminded me that I need to call the mother-in-law.'

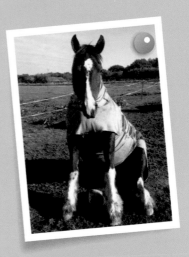

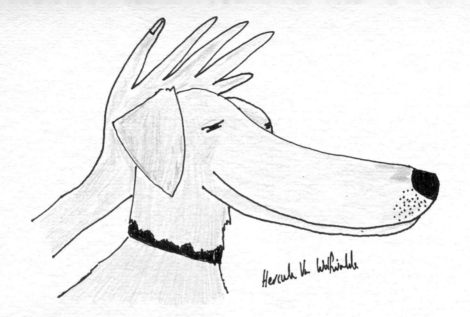

Hercule Van Wolfwinkle

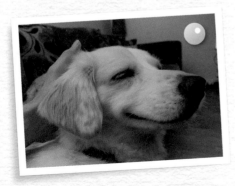

This sleepy smiler belongs to Katie. I don't know what she's called, but I've named her **Paris Stilton**.

**Review from the customer:** 'There's a saying by Friedrich Nietzsche that goes, "An artist has no home in Europe, except in Paris." You've never even been to Paris, have you?'

Hercule Va Wolfwinkle

**Review from the customer:**
'This was my daughter's mouse and he's recently died. Not only is my daughter having to process the emotions of losing her beloved pet, but she also now has to try to deal with experiencing crushing disappointment for the very first time. She's five years old.'

This little fella belongs to the lovely Lucy. I dunno what he's called, but I've been calling him **Ozzy** because of Ozzy Osbourne's famous song 'Cat Out of Hell'.

**Review from the customer:**
'I would do anything for love, but you can't draw cats.'

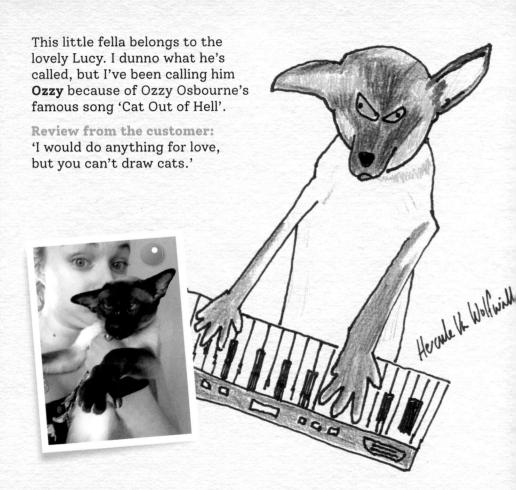

Hercule Vk Wolfgirl

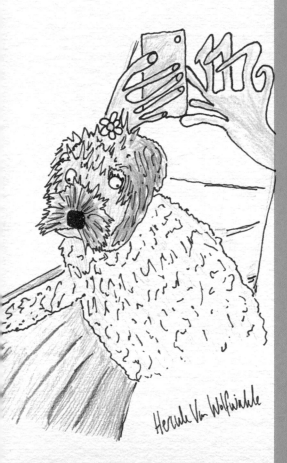

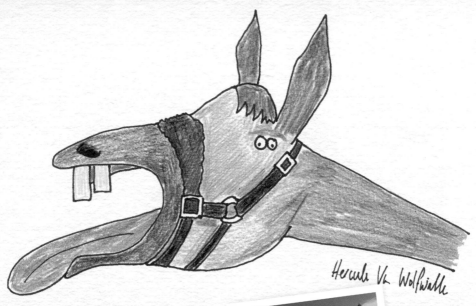

Hercule Van Wolfwinkle

This fella belongs to Megs, and whatever he's up to in this picture he's obviously enjoying it.

**Review from the customer:** 'There are so many things I want to scream at you and none of them are good.'

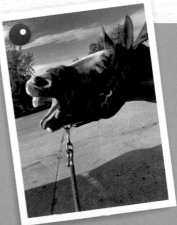

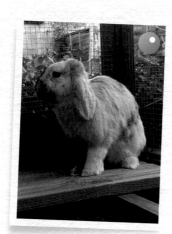

Don't think I've ever seen a rabbit this big before, but this one belongs to the lovely Abigail. I dunno what he's called, but I've named him **Justin Sharples**.

**Review from the customer:** 'Do we know each other? I don't think we've ever met, but I'm looking at this picture and wondering what the hell I've ever done to upset you.'

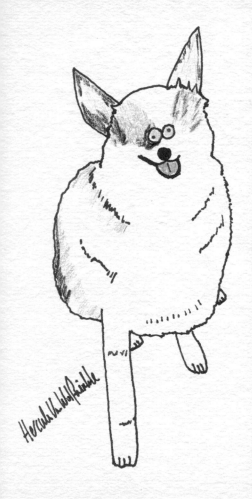

Erin contacted me and said, 'I'd love to see your rendition of "Delilah",' to which I replied, 'I don't know all the words to "Delilah", but I BELT OUT A CRACKING VERSION OF "WHAT'S NEW PUSSYCAT?"' It's funny because they're both Cliff Richards songs. Anyway, here is my rendition of **Delilah**.

**Review from the customer:** 'If your standards get any lower they'll probably end up underground. Which is probably where they belong.'

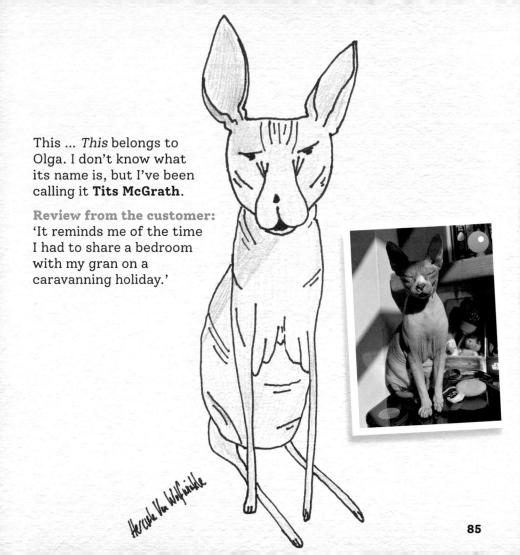

This ... *This* belongs to Olga. I don't know what its name is, but I've been calling it **Tits McGrath**.

**Review from the customer:** 'It reminds me of the time I had to share a bedroom with my gran on a caravanning holiday.'

Hercule Van Wolfwinkle

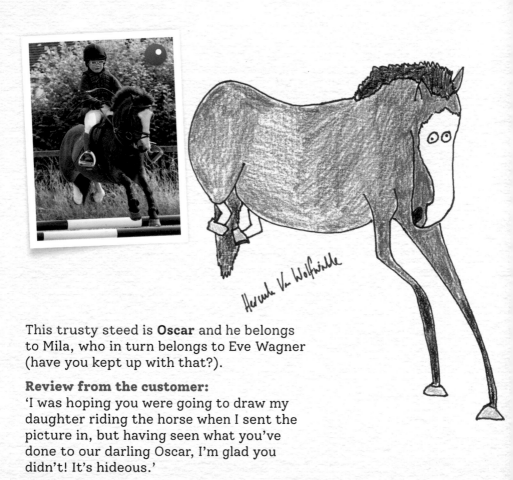

This trusty steed is **Oscar** and he belongs to Mila, who in turn belongs to Eve Wagner (have you kept up with that?).

**Review from the customer:**
'I was hoping you were going to draw my daughter riding the horse when I sent the picture in, but having seen what you've done to our darling Oscar, I'm glad you didn't! It's hideous.'

Bit of a frightening one here, so maybe don't show the kids. This is **Woody**, and he's a ghost dog who haunts the wonderful Hazel and her family.

**Review from the customer:** 'I'm not angry, I'm just disappointed.'

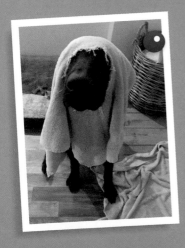

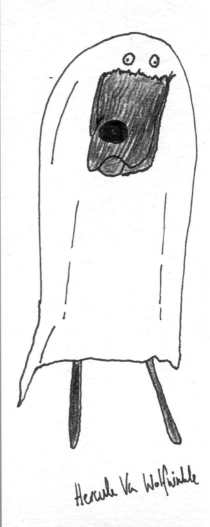

Hercule Van Wolfwinkle

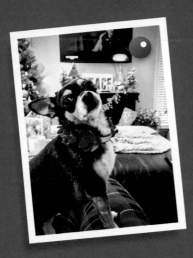

I've named this lady **Veronica Viennetta**. Veronica likes looking around corners, sleeping in nooks and shooing away the window cleaner.

**Review from the customer:**
'I actually want to thank you for this. It's helped me get over an ex-boyfriend I was hung up on. Now I realise there are things in life that I can hate more than him.'

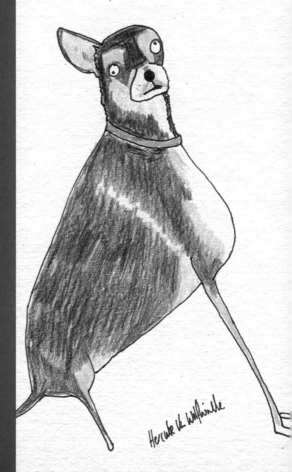

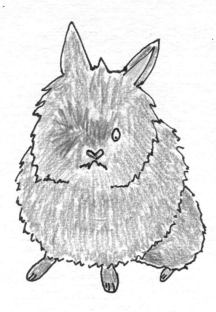

Another submission where I'm not entirely sure what I've drawn or even which end of it I've drawn. I hope I've drawn its face.

**Review from the customer:** 'I told the kids that Daddy had sorted the best surprise for them. They are super-excited to find out what it is. I'm going to have to buy them a Nintendo now, aren't I?! Thanks a lot!'

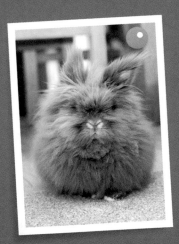

I went for my ultra-realistic style with this one as it really captures the bond between a pet and its owner. You might even struggle to tell these two images apart. But trust me, one of them is definitely my drawing.

**Review from the customer:**
'I can count on one hand six reasons why I hate this picture.'

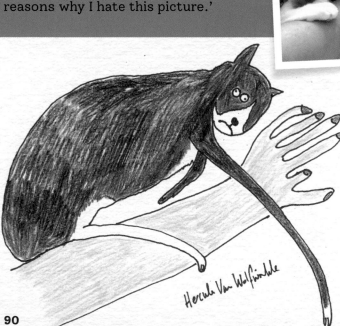

Hercule Van Wolfwinkle

This feathered friend belongs to the wonderful Debbie Knight. I don't know what his name is, but I've been calling him **Cuthbert Twiggs**.

**Review from the customer:** 'You were recommended to me by a friend. At least, I thought we were friends. Suffice to say I'll not be speaking to her again.'

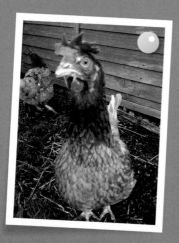

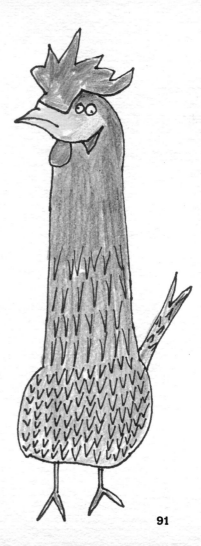

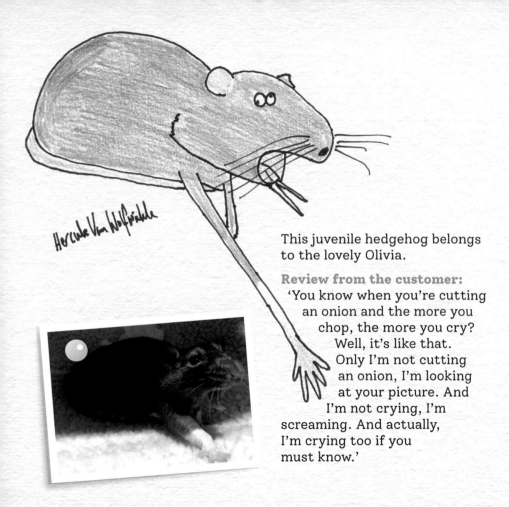

This juvenile hedgehog belongs to the lovely Olivia.

**Review from the customer:**
'You know when you're cutting an onion and the more you chop, the more you cry? Well, it's like that. Only I'm not cutting an onion, I'm looking at your picture. And I'm not crying, I'm screaming. And actually, I'm crying too if you must know.'

Hercule Van Wolfwinkle

This sensible-looking fella belongs to the wonderful Katherine. He loves walks in the rain and lazy Sunday mornings in bed with the *Hollyoaks* omnibus.

**Review from the customer:**
'I know you've been messaging my other half, but receiving your picture has induced one of her migraines so she's gone for a nap. Never message us again.'

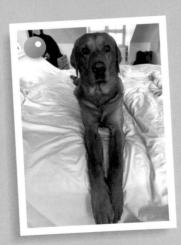

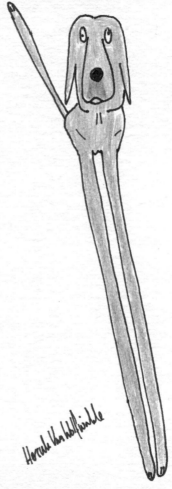

Hercule Van Wolfpinkle

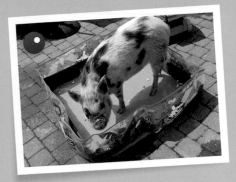

So it turns out some people, people like Sophie, keep fully grown pigs as house pets. Who knew?! I don't know what his actual name is, but I've been calling him **Dustbin Scoffman**.

**Review from the customer:** 'I'll let most things in my house, but this is going straight in the outside bin.'

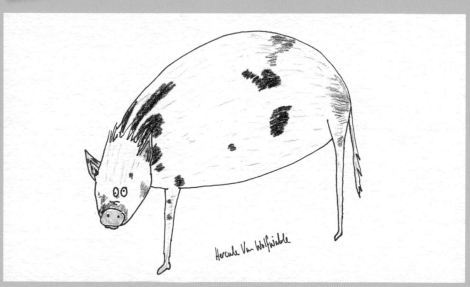

Hercule Van Wolfpinkle

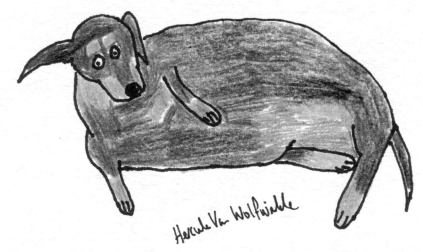

Hercule Van Wolfwinkle

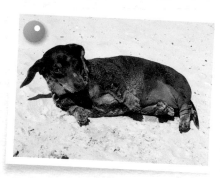

This request was sent in by Poppy. At first I was thinking, *For God's sake, Poppy, this is pet portraits not random wildlife portraits*, but then I realised I hadn't drawn a seal yet so thought I'd give it a go.

**Review from the customer:**
*'Why the hell would I have a pet seal?!'* [I don't know, Poppy, is it because you have a big garden?]

This pair are the housemates of Becca Thornburn. I've named them **Doreen LeManche** and **Trey Fernando**.

**Review from the customer:** 'I took this photograph from my lounge patio doors. I wish I'd just closed the curtains now. Except we don't actually have curtains on the patio doors. We're not overlooked, you see. Got bungalows out the back behind us.'

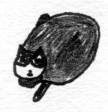

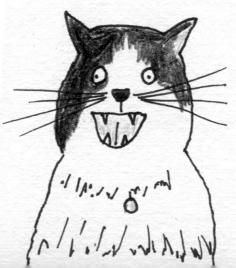

This relaxed fella belongs to Michael. I dunno what his name is but I've been calling him **Karl Calpol**.

**Review from the customer:** 'It looks like a slice of toast that's been dropped on a barber's floor.'

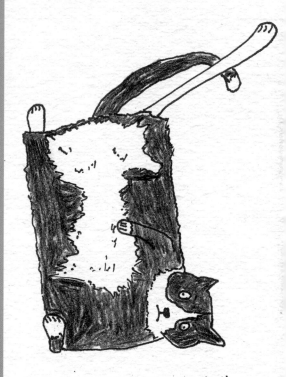

Hercule Van Wolfielle

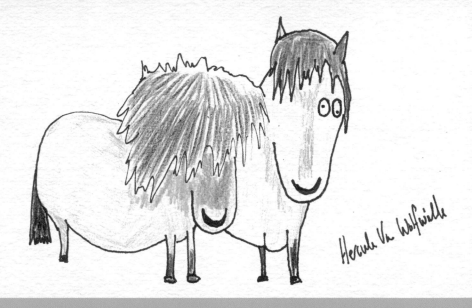

This pair belongs to Penny. I'm not overly sure what they are but I'm guessing some kind of rare breed pig, the Long-Haired Shropshire maybe. I've named them **Turner** and **Tina**.

**Review from the customer:**
'It's a mix of emotions. None of them good.'

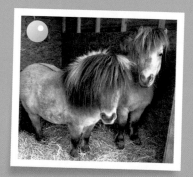

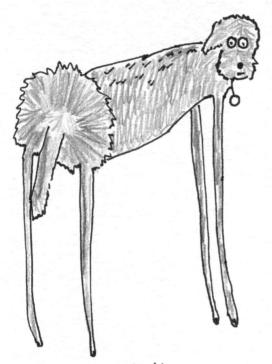

This beautiful creature belongs to Charlotte. I don't know what her name is, but I've been calling her **Sandra Sideburns**.

**Review from the customer:** 'I think it must've been damaged in the post. By "damaged", I mean drawn by a four-year-old.'

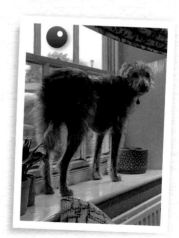

Hercule Van Wolfwinkle

99

I asked Mrs Van Wolfwinkle what colour this dog was and she said, 'Kind of like a dirty white'. I don't have 'a dirty white' crayon, so I've drawn it black and white.

**Review from the customer:** 'If I just look at his feet, literally his feet, it's OK. But even as I get to his ankles I start to shake with anger.'

Hercule Van Wolfwinkle

This dancing cat belongs to the lovely Caroline. I don't know what he's called, but I've named him **Michael Catley**.

**Review from the customer:** 'I know exactly where I'm going to put it in the house. The bin.'

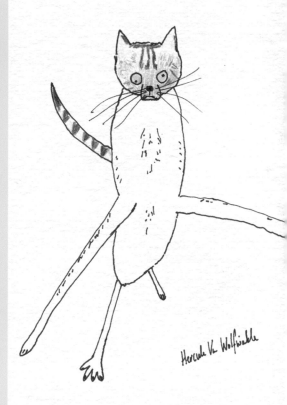

Hercule Van Wolfwinkle

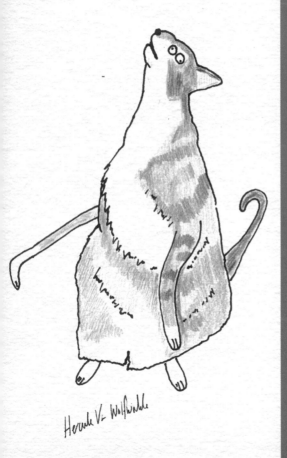

Hercule V. Wolfinkle

This is **Ko** the cat and he belongs to wonderful Hesse McKechnie. I'm told Ko lives in the Netherlands, which I think is close to Holland. Maybe next door.

**Review from the customer:** 'In the Netherlands we have a saying: "Kan niet geloven dat je de tijd hebt genomen om dit te vertalen!" Veel liefde, Hercule.'

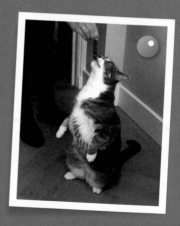

This request came in from Melanie for her daughter's pet **Cloud**. The hamster is called Cloud, she doesn't have a pet cloud ... I think. Obviously I'm well practised at drawing human hands, and I think I've got my first hamster spot on too!

**Review from the customer:**
'I can't believe this doesn't come with a health warning. I have to show this to my child.'

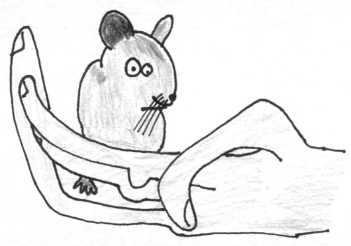

Hercule Van Wolfwinkle

This athletic chap belongs to Louise. I don't know what his name is, but I've been calling him **Tony Dancer**. In the words of the great Elton John, 'Throw a bone for Tony Dancer ...'

**Review from the customer:** 'Is it possible to be allergic to a picture? Every time I look at it my eyes close and I get a lump in my throat.'

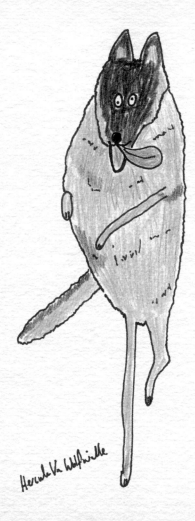

Hercule Van Wolfwinkle

I've named this pooch **Cassius Stay**. I couldn't draw this in my usual ultra-realistic style as I had to put a pair of pants on him. I mean, I'm no vet, but I'm assuming he's a boy.

**Review from the customer:** 'It's ironic that you chose to censor parts of your portraits when they're all so offensive.'

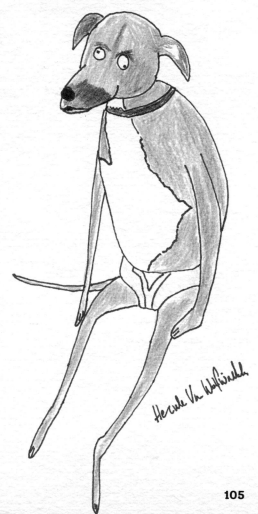

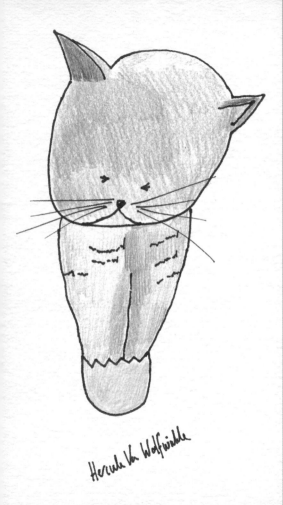

Hercule Van Wolfwinkle

This is **Nelly** and she belongs to Shari Day. I love this picture taken on Nelly's hatching day, so I just had to re-create it in my ultra-realistic style. You can almost hear the commentary of David Attenborough as you look at the drawing.

**Review from the customer:** 'You're not a vet. And you're obviously not an artist. What are you?!'

This beautiful cat belongs to Joanna. I've named her **Olivia Ovaltine**. Ms Ovaltine is no stranger to a bit of fame as she once appeared in the local newspaper at a protest about the closure of the public toilets.

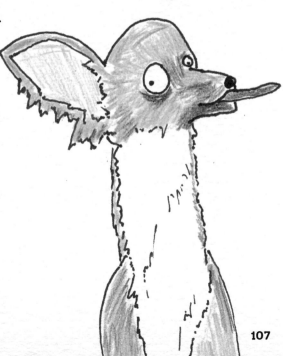

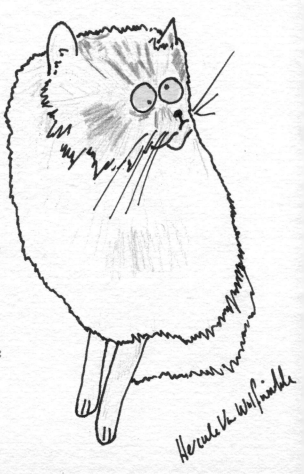

This fluffball belongs to the wonderful Frances Foot. Again, I'm not 100 per cent sure what she's called, but I've named her **Luce Stringbean**.

**Review from the customer:** 'If the RSPCA see your drawing they'll probably take her away from me.'

I've named this pooch in the photo that was submitted **Rpoo-Pee2**.

**Review from the customer:**
'I've chucked it straight in the bin and then moved the bin out onto the street because I need it as far away from the house as possible. Now Ken and Barbara at number 33 have put their bin out too because they think it must be bin day, and the net curtains are twitching nervously at number 35.'

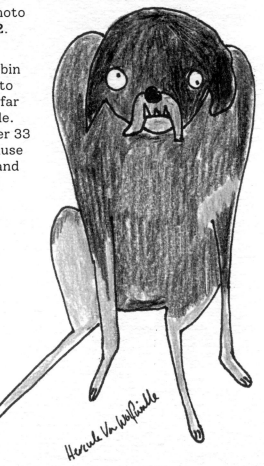

This cat in a sink reminds me of some sage advice I was once given: pour shampoo and conditioner down your plugholes every now and again to leave all of the hairs blocking them up feeling clean and nourished.

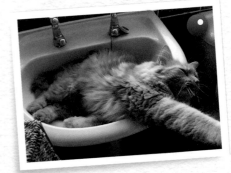

**Review from the customer:**
'I haven't experienced disappointment like this since that Christmas I really wanted a Mr Frosty. And I got one. And it was shit.'

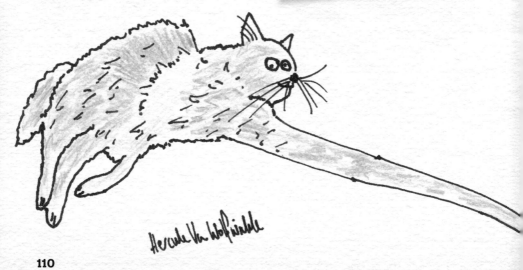

Hercule Van Wolfwinkle

I've named these **Disco Ryan** and **Sangria Sue**. Disco is a fun-loving cat who likes to play, but Sangria Sue is older in years and should not be approached after 2 p.m.

**Review from the customer:** 'My girlfriend won't stop crying and yelling at me to fix it. I don't know what to do, but I've called 111. This is going to set off her allergies.'

Hercule Van Wolfwinkle

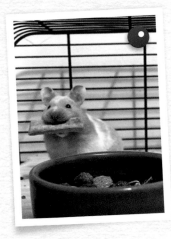

I've had to use all of my artistry to imagine what a Chihuahua would look like without a Dentastix in its mouth. I think I've nailed it.

**Review from the customer:**
'It's arrived just in time as it's bin day tomorrow. Which will be an even bigger relief for Ken and Barbara at number 33, who've had their bins out for five days.'

It's been suggested that I should start trying to draw a bit more of the 'background' in images as opposed to just the animal. This isn't 'Pet and Other Items Photographed Portraits by Hercule', but I thought I'd give it a go nonetheless.

**Review from the customer:**
'I think I'll probably learn to love it in time. Like when the cataract gets really bad.'

Hercule V. Wolfinville

I've named this chap **Slippery Eddie**. Eddie is pictured here on his 21st birthday. The family had a lovely weekend away in the static caravan and Eddie was able to bring two friends.

**Review from the customer:** 'My dog isn't even smiling at this. And that's almost physically impossible. Are you proud of this?'

Hercule the Wolfiedelle

I've named this handsome chap **Sidney Succulent**.

**Review from the customer:**
'Have you heard the phrase, "Give a man a fish and he'll eat for a day. But teach a man to fish and he'll eat for a lifetime"? Well, that has no relevance at all to your drawings except for the fact that I wondered if you had considered taking up fishing instead.'

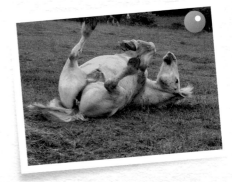

Hercule Van Wolfswinkle

This gorgeous little kitten belongs to the wonderful Tallulah Edwards. I don't know what her name is, but I've been calling her **Whiskers Dice**.

**Review from the customer:** 'Please give your wife my number and tell her that I'm always available to chat. I can't even begin to imagine what living with you is like.'

This handsome fella belongs to the lovely Karen Dion. I dunno what his name is, but I've called him **Piggy Stardust**.

**Review from the customer:** 'You know pigs will eat almost anything? Well, I think this would even turn his stomach; it's disgusting.'

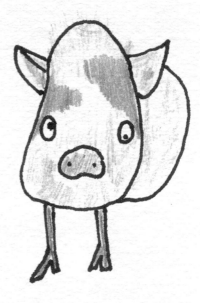

Hercule Van Wolfswinkle

This lovely little Jack Russell belongs to Emily. I don't know what she's called, but I've named her **Jennifer Caniston**.

**Review from the customer:**
'This was going to be a birthday gift for my child. I haven't got time to sort anything else, so now I'm going to have to pretend I've forgotten her birthday. Nice one, mate.'

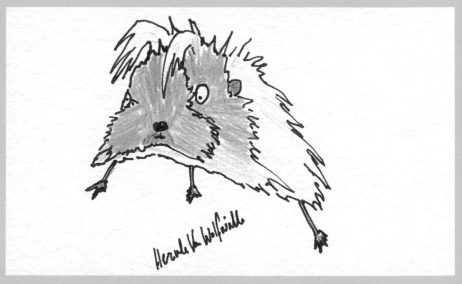

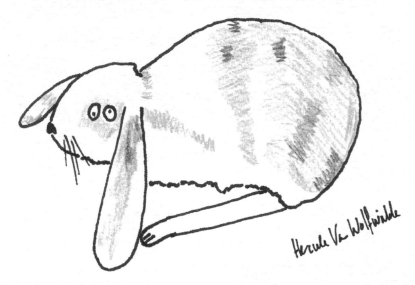

Hercule Van Wolfwinkle

This beautiful rabbit belongs to Sarah McQuillan's lovely daughter. Her name is **Crunchie** (the rabbit, not Sarah's daughter).

**Review from the customer:** 'My daughter is asleep now. I'm going to wake her up, show her the picture briefly and then in the morning we can just pretend it was an awful nightmare.'

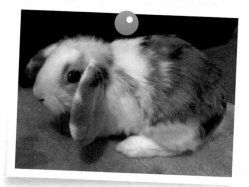

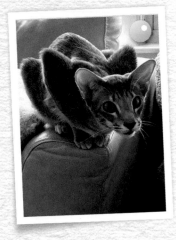

This mischievous-looking creature belongs to Allie Jane. I don't know what his name is but I've been calling him **Leonardo Caprichos**. Leo likes pouncing at the milkman, chasing vans and mooching around the charity shops.

**Review from the customer:** 'Do you draw these standing 50 feet away from the original picture?'

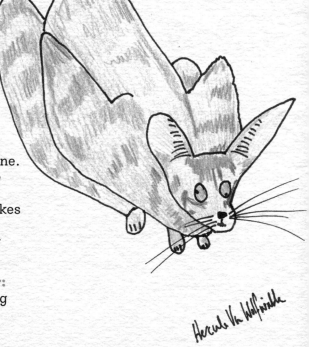

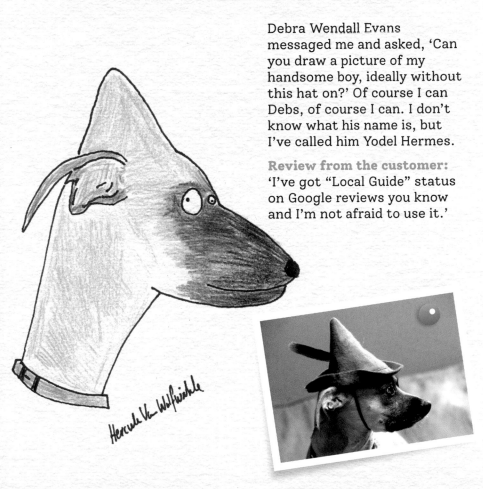

Debra Wendall Evans messaged me and asked, 'Can you draw a picture of my handsome boy, ideally without this hat on?' Of course I can Debs, of course I can. I don't know what his name is, but I've called him Yodel Hermes.

**Review from the customer:** 'I've got "Local Guide" status on Google reviews you know and I'm not afraid to use it.'

Hercule Van Wolfbichle

This is **Pippa**. Pippa likes running till her tongue hangs out, jumping over fences and an extra dollop of lime pickle on her Friday-night takeaway.

**Review from the customer:** 'It looks OK on my phone. With the screen light turned down as low as possible. And the power turned off.'

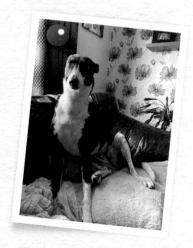

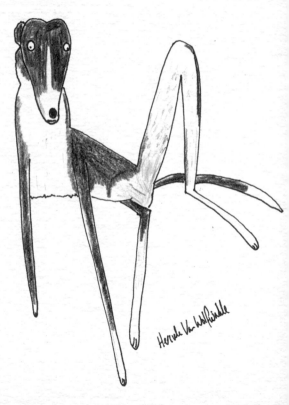

Well, this is the first camel I've ever drawn! He belongs to the lovely Alison and I've named him **Humphrey Stobart**. He's just a baby, which is probably why he hasn't got his hump yet. That comes in the teenage years!

**Review from the customer:** 'It looks like a pantomime horse.'

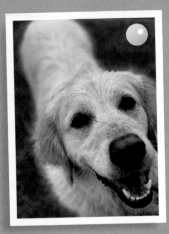

Beautiful **Jess** belongs to Matt, the very first person to donate to my fundraiser. For that I will be eternally grateful.

**Review from the customer:**
'It's like one of those nightmares where nothing really bad happens as such, but there's just a constant feeling of impending doom. I get similar emotions looking at this. Only there's loads of bad stuff happening too.'

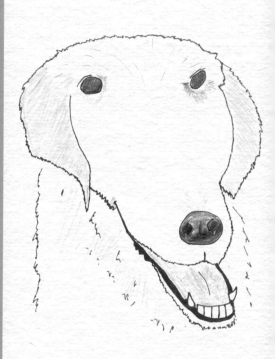

**124**

# Acknowledgements

First, I'd like to thank *you*. Oh no, hang on … Not you; I thought you were someone else.

My first thanks must go to my long-suffering wife, Ashley, and our son, Sam. You have both lost me to hours upon hours of paper and crayons over these last few months. I am sorry for that, but I also hope that we've all had some fun together on this crazy adventure and I'm excited to see where it will take us next.

Staying in the family, I'd also like to thank our dog Narla for being the inspiration for the first portrait that started all of this. She's a pain in the arse, but we love her. (I would consider serious cash offers for her, though.)

To my extended family and close friends (you know who you are), thank you for putting up with me on all the group chats and for keeping me straight when I've wobbled. I particularly recall one 6 a.m. phone call with Nick when I was close to just jacking it all in. Thanks for always being there.

To Kaylea and Matt and Dan and Jeanie and Nick and Ingrid and all of the other wonderful people who got behind the project in its infancy, and subsequently to the thousands of folk who have joined us with kind words, great humour and generous donations to the fundraising. If you guys didn't support me, I wouldn't have had this opportunity and I will never be able to thank you all enough for that. Hopefully because we'll never actually meet.

Thanks to the good folk at Caroline Wakeman Literary Agency, but particularly Kate Johnson for all your hard work, support and unwavering faith in my ability! Even during the times when you told me I was shit, I knew you were only joking.

A huge thanks to everyone at HarperCollins. First, to Tiff, Faith and Harriet for believing in the idea and taking a chance on this book, then to the amazing Anna, who has led the project and held my hand throughout. I hope I get to work with you on the second, third and fourth books too …

Last, but by no means least, a massive heartfelt *thank you* to everyone at Turning Tides! Lucy, Gem, Sophie and Abi: you are all superstars who work tirelessly. Ben, you are an inspiration and your story has kept me going many times throughout the fundraising. If there was an award for just being brilliant, you should all win it. To the rest of the Turning Tides staff and volunteers, thank you for the invaluable work you do for the folk who need it.

Oh, and before you go, thank *you*. I was only joking earlier. Of course I knew it was you really! Thank you so much for spending your hard-earned cash on this little book of mine. I hope you've enjoyed it. I hope it's raised a smile and I hope to see you again soon.

Much love, Hercule xx

**www.justgiving.com/fundraising/ portraitsbyhercule**

# Picture credits

While every effort has been made to trace the owners of copyright material reproduced herein and secure permissions, the publishers would like to apologise for any omissions and will be pleased to incorporate missing acknowledgements in any future edition of this book.

HarperCollinsPublishers
1 London Bridge Street
London SE1 9GF

www.harpercollins.co.uk

HarperCollinsPublishers
1st Floor, Watermarque Building,
Ringsend Road, Dublin 4, Ireland

First published by HarperCollinsPublishers 2021

10 9 8 7 6 5 4 3 2

A catalogue record of this book is available from the British Library

ISBN 978-0-00-846816-3

Designed by Bobby Birchall, Bobby&Co, London
Printed and bound in Latvia

MIX
Paper from responsible sources
FSC™ C007454

This book is produced from independently certified FSC™ paper to ensure responsible forest management.

For more information visit:
www.harpercollins.co.uk/green